this BOOK belongs TO

W9-DJP-214

BE HAPPY
JUST ADD WATER

THUNDER BAY
P·R·E·S·S
San Diego, California

Thunder Bay Press
An imprint of Printers Row Publishing Group
9717 Pacific Heights Blvd, San Diego, CA 92121
www.thunderbaybooks.com
mail@thunderbaybooks.com

Printers Row Publishing Group is a division of Readerlink Distribution Services, LLC. Thunder Bay Press is a registered trademark of Readerlink Distribution Services, LLC.

Correspondence regarding the content of this book should be sent to Thunder Bay Press, Editorial Department, at the above address. Author and rights inquiries should be addressed to Quarto Publishing plc.

Conceived, edited, and designed by
Quarto Publishing plc,
6 Blundell Street, London, N7 9BH, UK.

Thunder Bay Press
Publisher: Peter Norton
Associate Publisher: Ana Parker
Publishing/Editorial Team: April Farr, Kelly Larsen, Kathryn C. Dalby
Editorial Team: JoAnn Padgett, Melinda Allman, Dan Mansfield

Quarto Publishing
Senior Designer: Martina Calvio
Illustrator: Kuo Kang Chen
Editorial Assistant: Cassie Lawrence
Publisher: Samantha Warrington

ISBN: 978-1-68412-577-7

Manufactured in Malaysia

25 24 23 22 21 6 7 8 9 10

Credits

vasara/Shutterstock.com; NatSmith1/ Shutterstock.com; S.Noree Saisalam/ Shutterstock.com; NatalieBakunina/ Shutterstock.com; Katika/Shutterstock. com; Nilmerg/Shutterstock.com; Jane-Lane/Shutterstock.com; StockSmartStart/Shutterstock.com; molua/Shutterstock.com; Anastasia Mazeina/Shutterstock.com; mis-Tery/ Shutterstock.com; mcherevan/Shutterstock. com; Minur/Shutterstock.com; Verock/ Shutterstock.com; Julia Snegireva/ Shutterstock.com; AuraArt/Shutterstock.com; Katakata/Shutterstock.com; A.I/Shutterstock. com; Bimbim/Shutterstock.com; Zakharchenko Anna/Shutterstock.com; Anchalee Ar/Shutterstock.com; Eva Kali/ Shutterstock.com; An Vino/Shutterstock.com; Topotovska Nataliia/Shutterstock.com; SMIRNOVA IRINA/Shutterstock.com; Irina Romanova/Shutterstock.com; Oksana Alekseeva/Shutterstock.com; karakotsya/ Shutterstock.com.

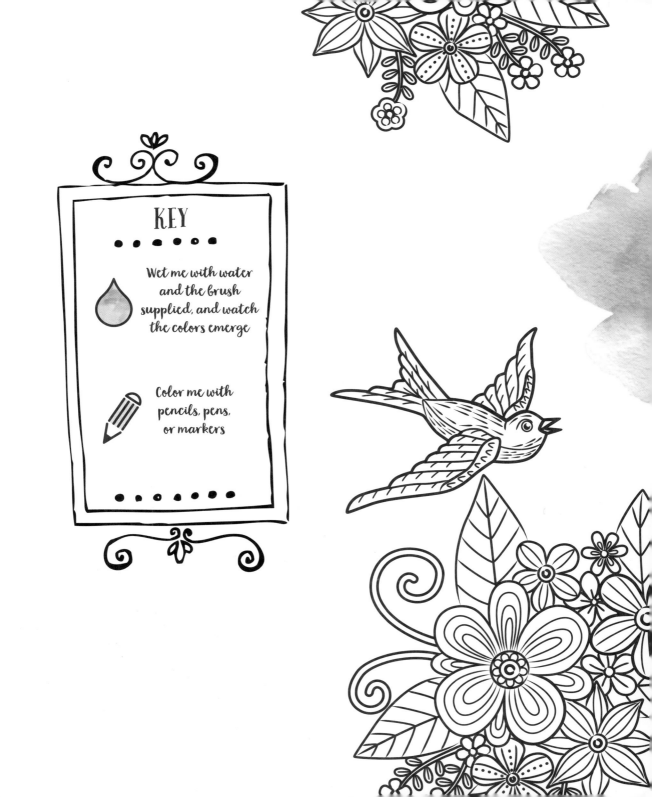

KEY

· · · · · · ·

Wet me with water
and the brush
supplied, and watch
the colors emerge

Color me with
pencils, pens,
or markers

· · · · · · · ·

About this book

This book contains life-affirming statements illustrated with fabulous art that requires no more than the application of a wet paintbrush to spring to life! Start by selecting an affirmation that best matches how you want to feel (experts say that repeating positive mantras can reprogram your subconscious mind and encourage feelings of well-being and positivity). Look to see if the subject is a "magic painting" or one that requires dry media to color it in. Then follow the instructions below.

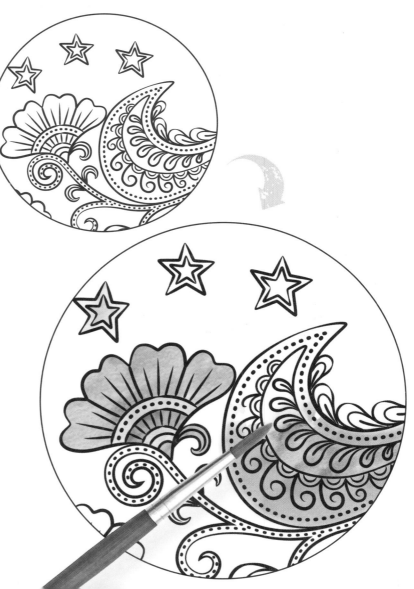

 MAGIC PAINTING

❋ 1 Slip the back cover flap beneath your chosen painting to prevent water from seeping through.

❋ 2 Dip the brush tip in clean water and gently apply the brush to the black linework. Most black lines release colorful pigment, though some are there just to act as outlines. Follow the lines. Avoid overwetting the artwork. Relax! Take your time. Watch as different colors emerge and mix together on the page.

❋ 3 Carefully tear out your painting along the perforated edge. Leave the painting to dry flat. Then put it on display!

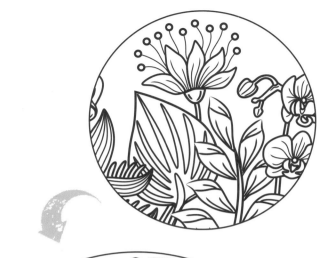

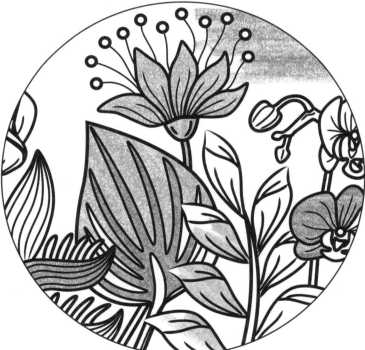

✏️ TRADITIONAL COLORING-IN

❋ **1** Slip the back cover flap beneath your chosen picture to prevent the images beneath from being dented, if you press down heavily with your colored pencils.

❋ **2** Choose between pencils, pens, or markers. When working with colored pencils, build up rich and varied color effects by mixing colored pencils on the paper surface. Vary the pressure of the pencil point to affect the depth of color.

❋ **3** Once your artwork is complete, carefully tear out your picture along the perforated edge. Then put it on display!

HAVE
fun!

I ATTRACT
loving relationships
INTO MY life

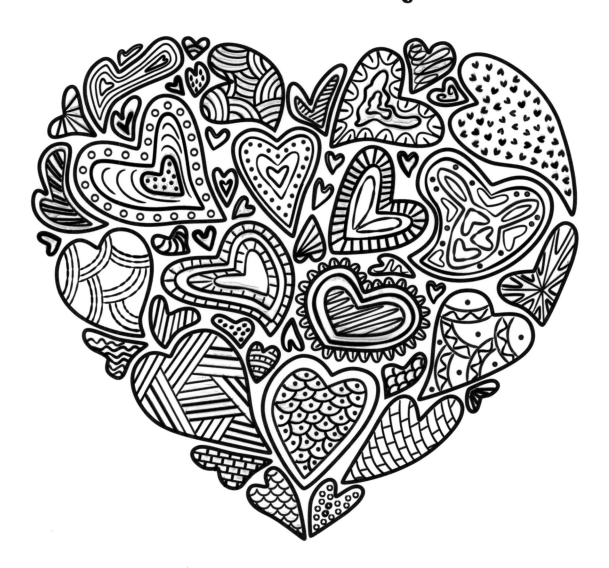

I EMBRACE PEACE AND SERENITY

I can SHARE my HAPPINESS with OTHERS

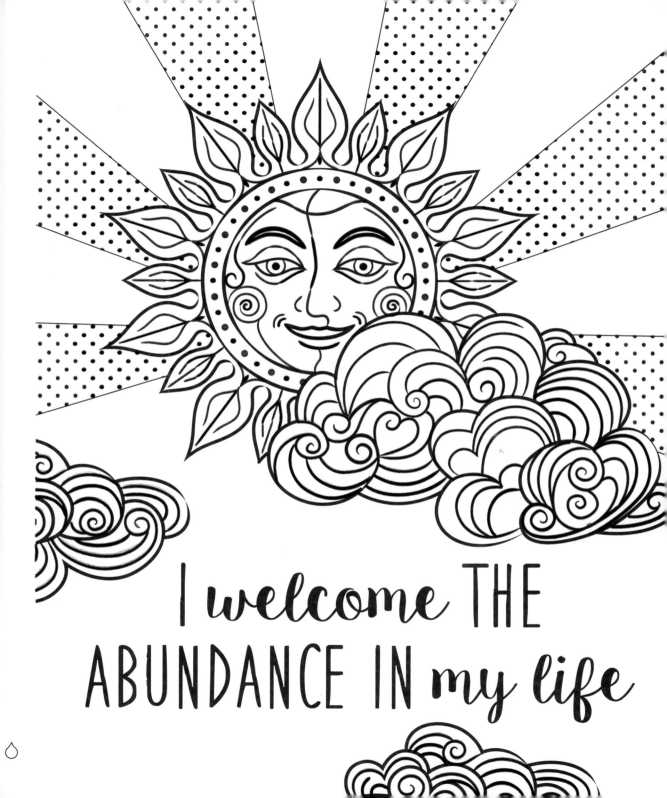

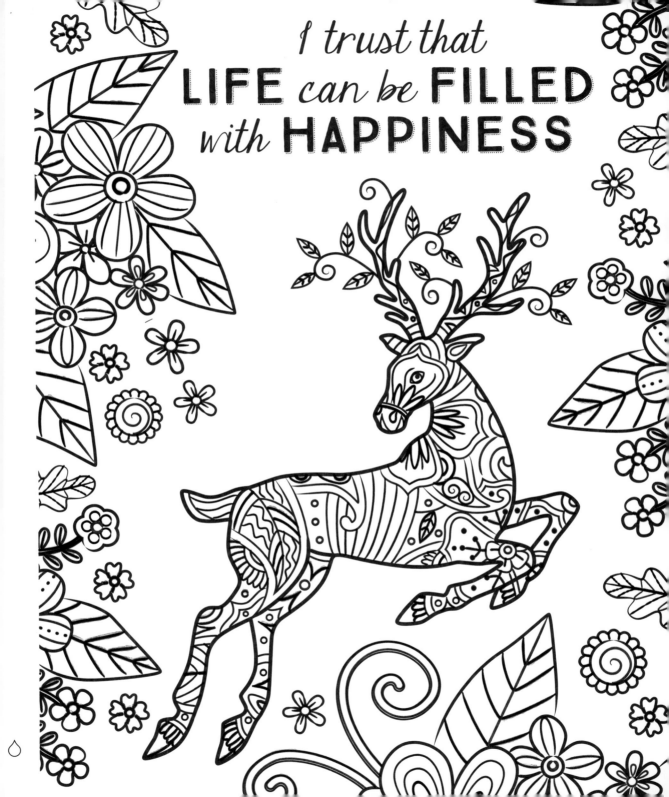

My mind is STRONG, POSITIVE, and FOCUSED

I DELIGHT in the SIMPLE things in LIFE

I am a STAR and I DESERVE to SHINE

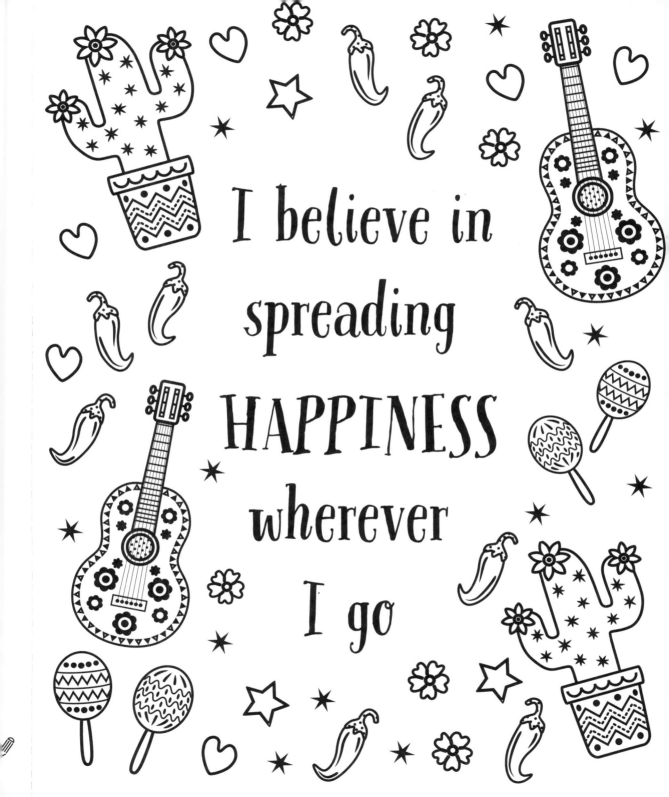

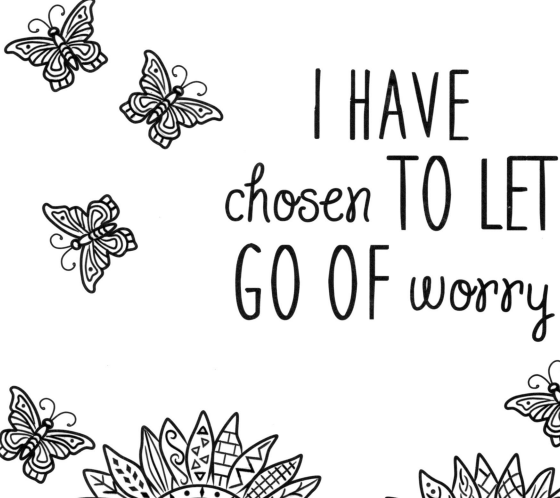

I HAVE chosen TO LET GO OF worry

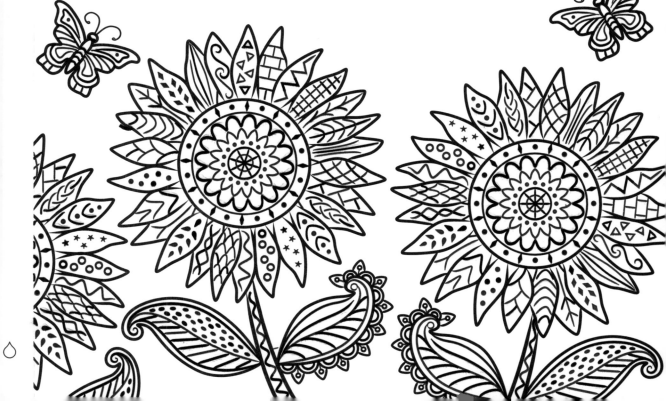

EVERY NIGHT
I CAN COUNT MY *blessings*

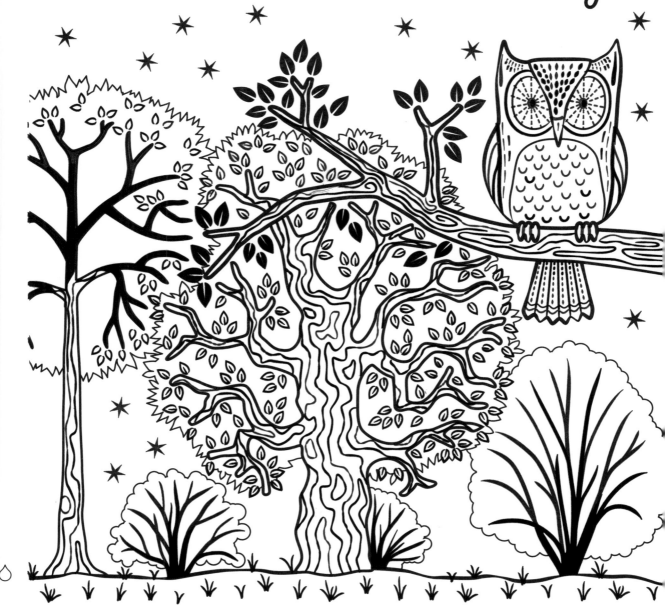

I DESERVE THE *good things* THAT COME MY WAY

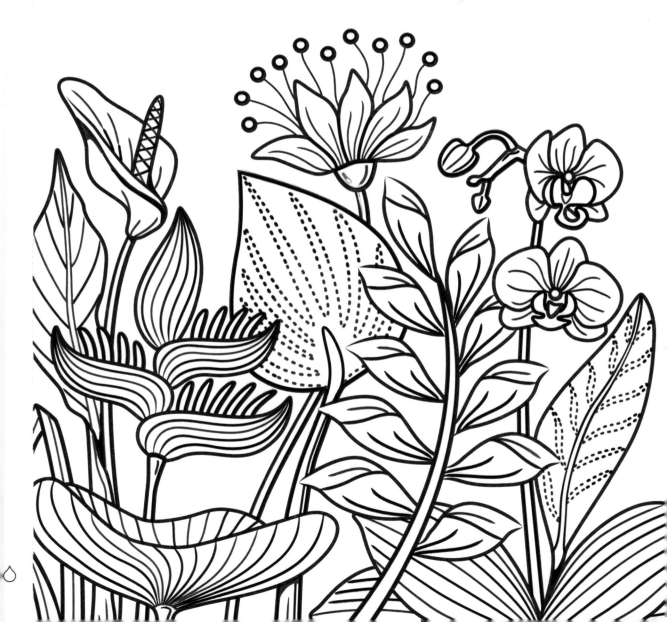

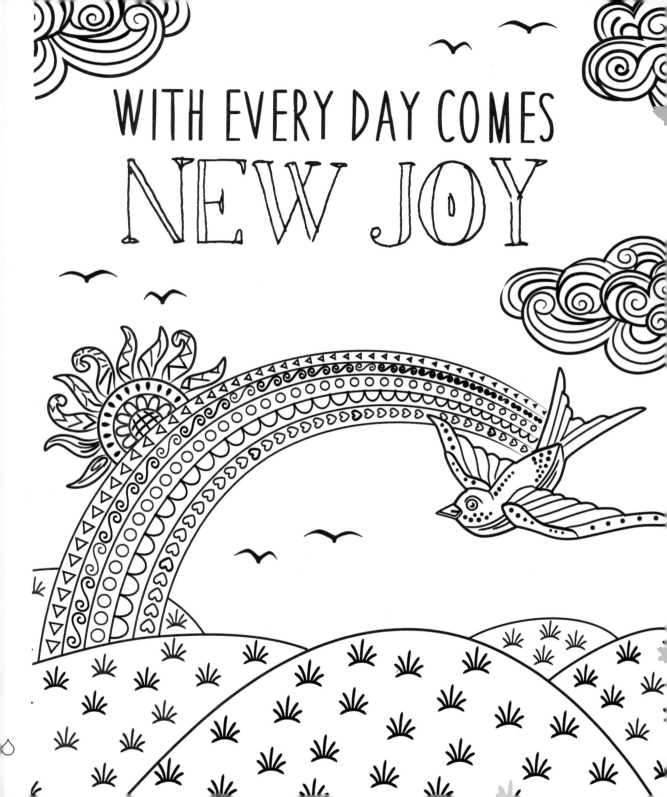

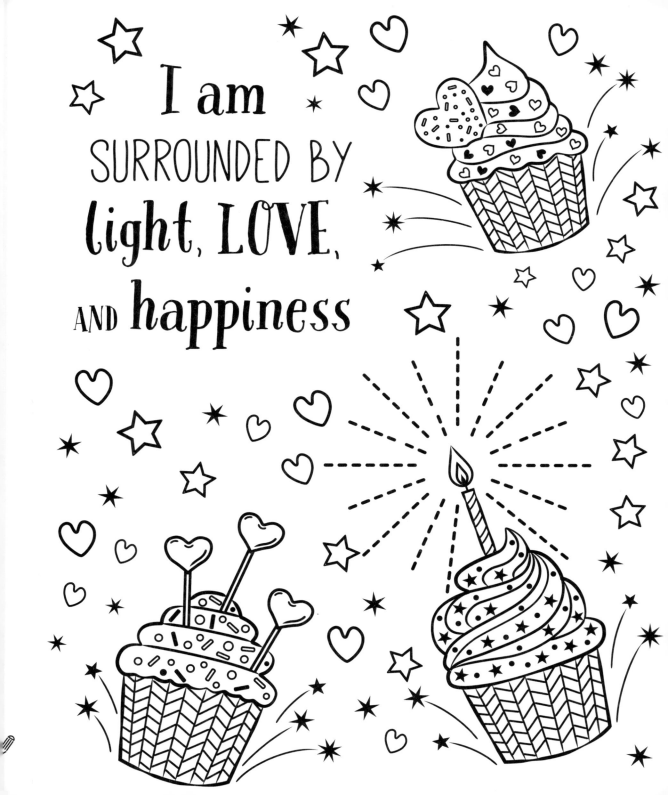

I am
SURROUNDED BY
light, LOVE,
AND happiness

My life IS FILLED WITH joyful SURPRISES

EVERY DAY my LIFE GETS...

...BETTER and BETTER

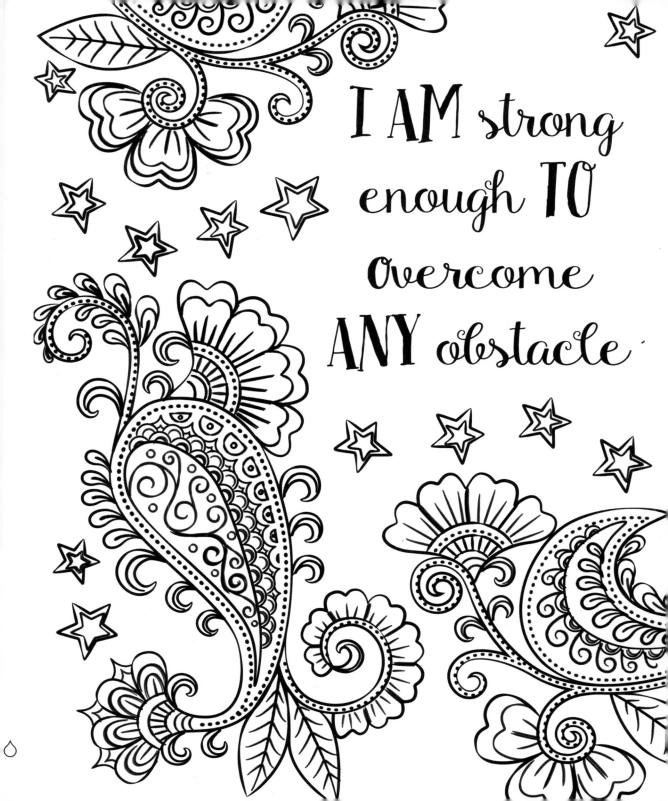

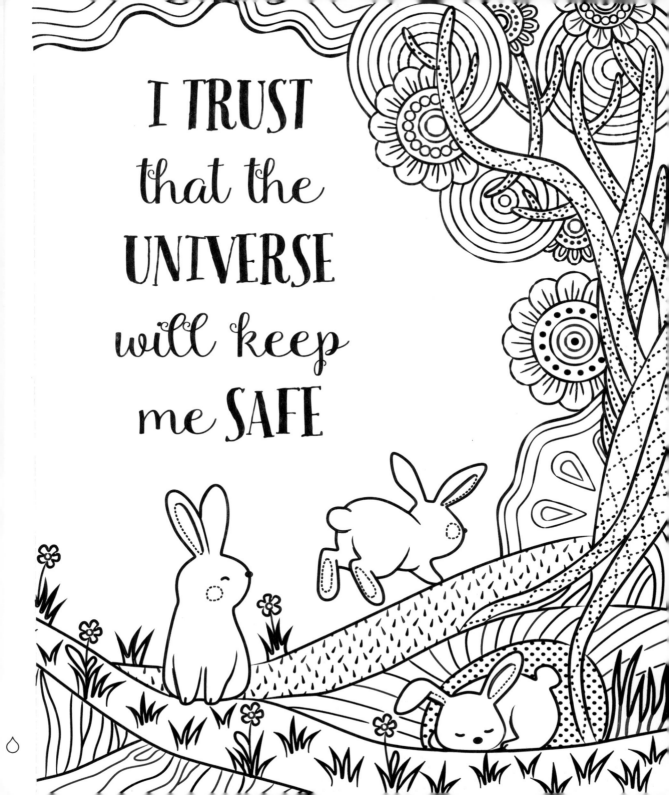

I CHOOSE TO ADOPT
a calm APPROACH
TO LIFE

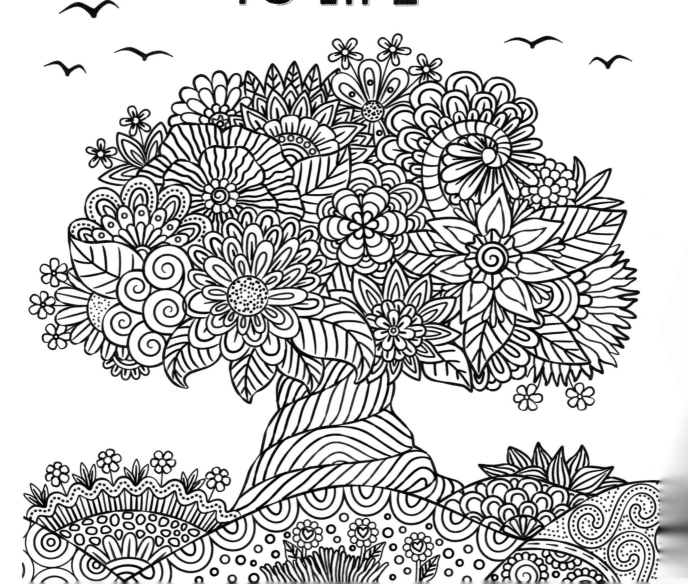

I know THAT I AM *worthy* OF BEING LOVED

I
APPROACH
each day WITH
CHILDLIKE
wonder

I CAN ENJOY the good times because I DESERVE them

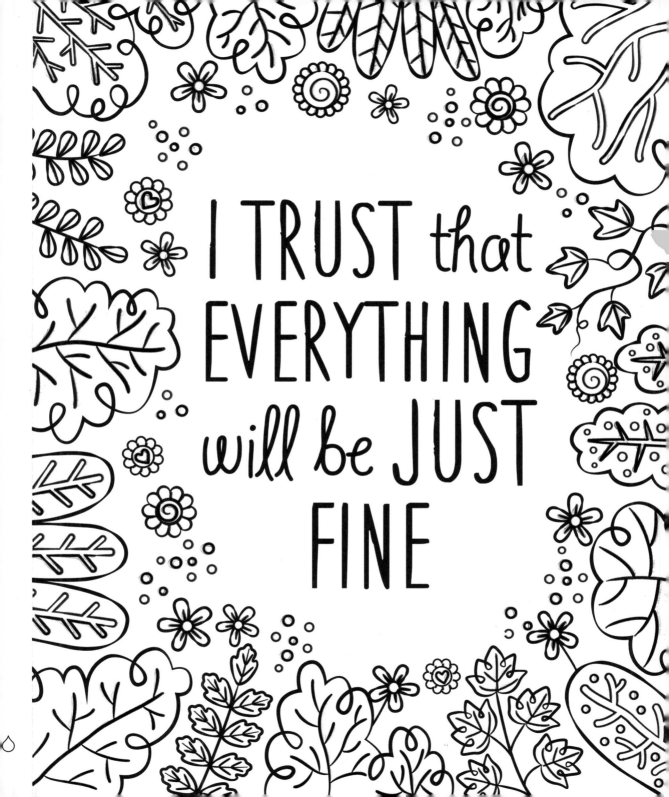

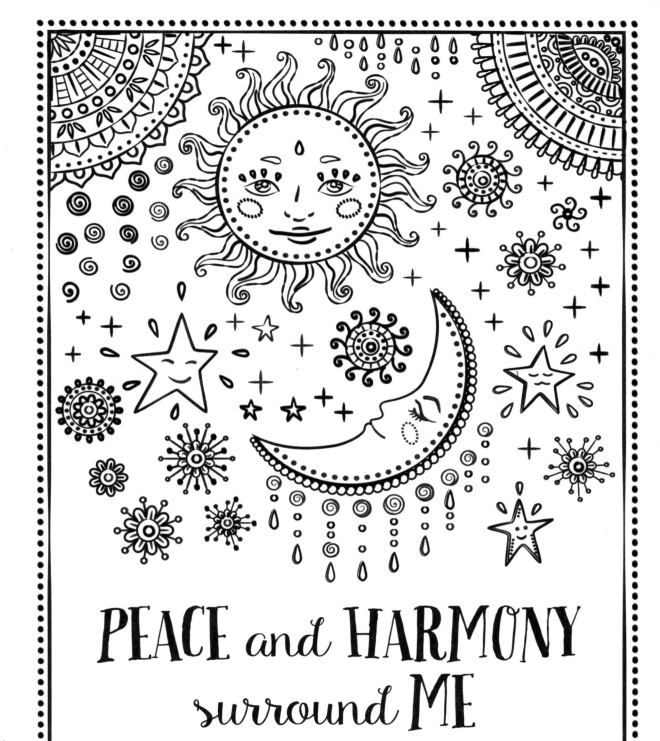

PEACE and HARMONY surround ME

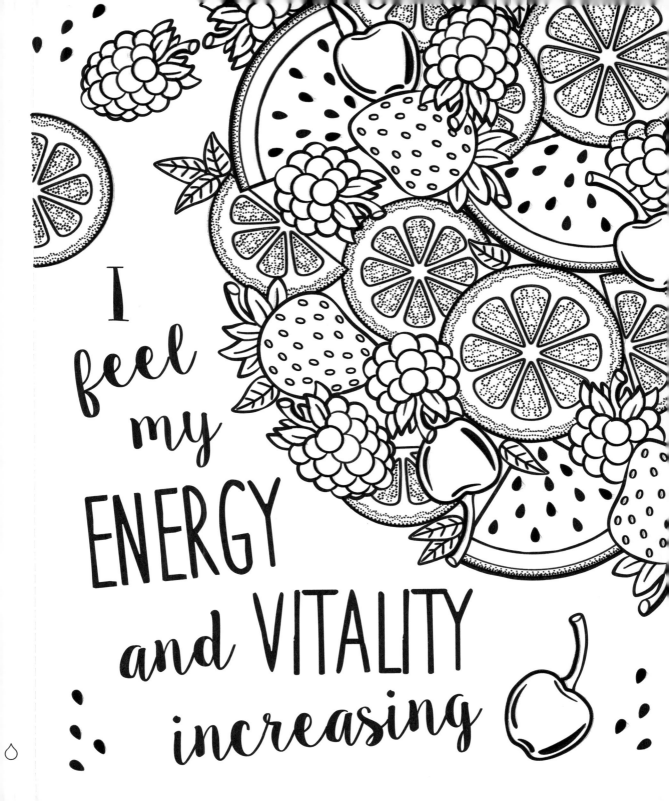

I feel my ENERGY and VITALITY increasing

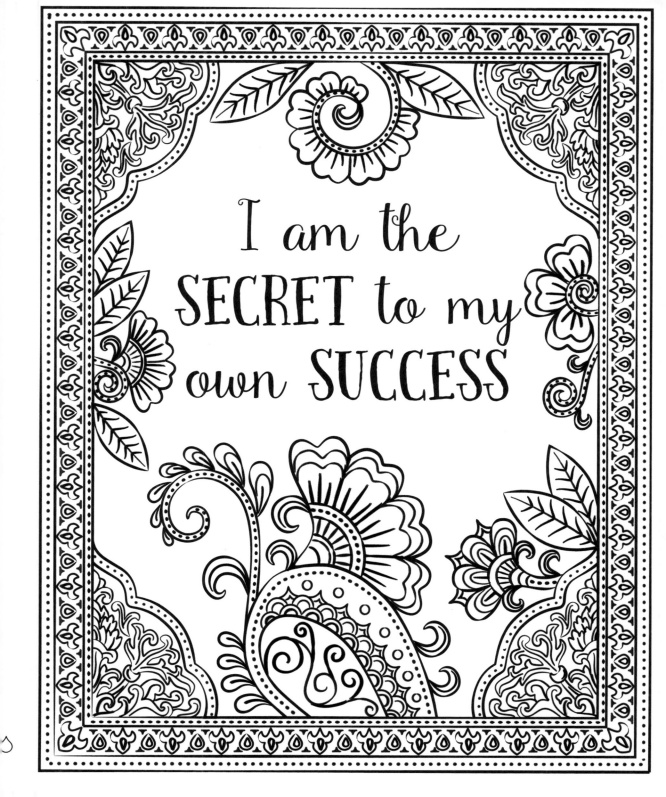

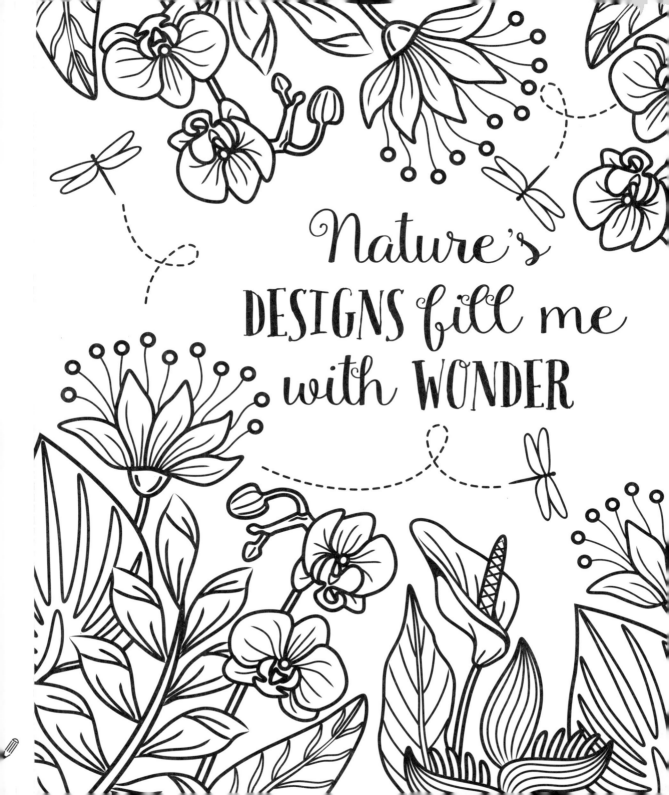

I choose to always notice the beauty that surrounds me

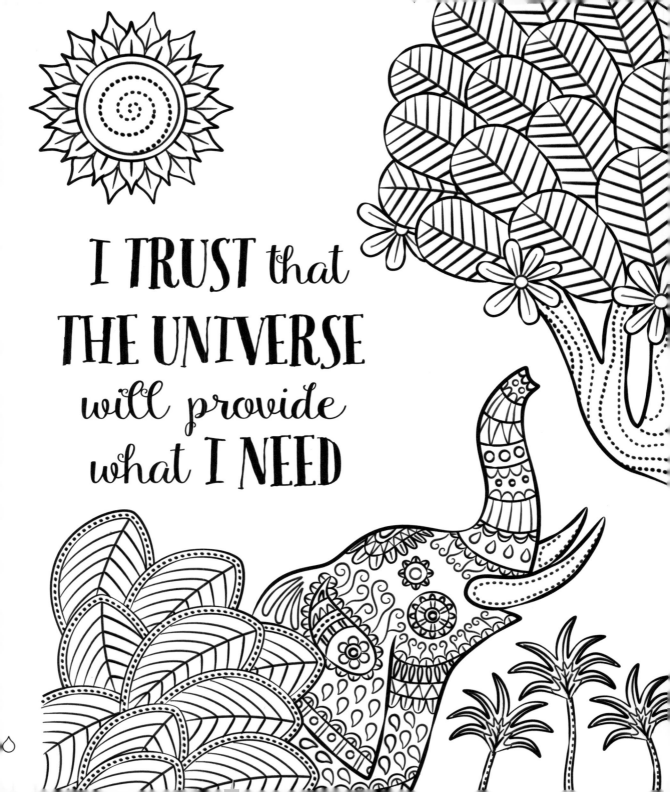

I BELIEVE in my DREAMS

I CREATE A HAPPY
LIFE FOR MYSELF